MAGNIFICENT MESS

MESS TOPHER KEARBY

Words and Art by Topher Kearby
www.TopherKearby.com

Edited by Topher Kearby
&
Christina Hart

Cover Design by Adam Farster
www.AdamFarster.com

ISBN: 978-0-692-79833-1

Second Trade Paperback Edition
Printed in the United States of America

**Gray Force
Publishing**

stand still and
die in your tracks
watching swallows
swallow
gulps of silk air
while you drift
unaware
into the next
ever after

hurry fast and
quicken the haste of
the few steps that
remain
gaze as time flies
effortlessly
by the dreams and plans
so meticulously
crafted but never
realized

stand and hurry
walk and run

waiting for
tomorrow
is never done

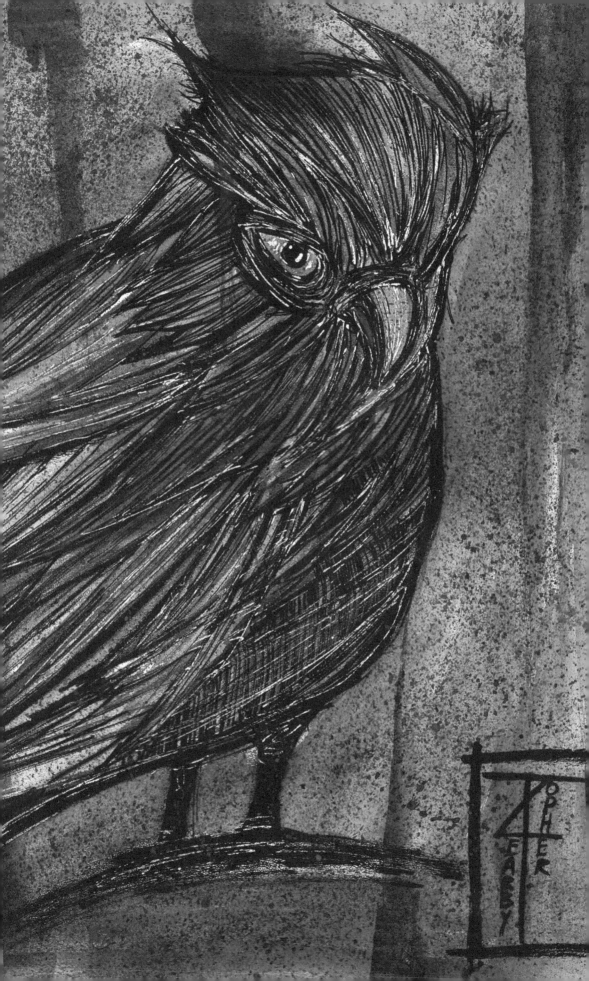

fell in love with the wind
became entranced understanding
where it's going
and where it's been

the movement and pace
the hidden body and face
the mystery behind a hidden
history of life
- the unknown -

it was easy to love
easy to want
easy to picture a life
spent with the unidentified
versus a relationship
with the recognized

that's why so many lust
after the wind
and so few love one another
for longer than a moment
- together -
choosing not to walk into
a beautiful forever

desiring a gust that incessantly
changes and rearranges
into whatever our minds want
to believe

LUST FOR THE WIND

SOMEHOW WHEN WE ARE TOGETHER WE BECOME EVERYTHING

whispers are like nuclear bombs

scattered

and dropped

they shatter

and destroy

friendships and relationships

words

softly spoken to another

about another

noting failings

and shortcomings

never spoken to a face

always just over

a passing shoulder

as if no one could ever know

what truth a whisper

ever spoke

but here we are

all victims of the blast

left to choke

NUCLEAR

Spoiled

i spoil my girls
because childhood is short
the world is often hard
and i am their father

i let them stay up late

watch cartoons
and buy them ICEES each
time we go to Target

i hold them when they cry
and tuck them in each night
and praise them for the simple
things they do

because i know
one day they'll be on their own
and someone will say or do
something cruel

then they'll know where
to come back

to be spoiled
to be safe
to be loved without conditions

locked tightly
in their father's arms.

drink in the drunken splendor
of a forest filled with imps
and fawns.
let go of your ideas
of the many things that *are*
and, instead, focus on the *what*
could be – behind the rows of
steel beams, and beneath the
concrete pathways.

you are a dreamer.
a poet.
a writer.
a voice.

set free worlds that only
you know and the things
and people that will fill them
with wonder.

put fingers to keys and
pens to paper.
bring your
imagination to life.

writers

Opposite of Me

she walked in a haze,
bag over her left shoulder,
unzipped and spilling her life's details
out for anyone looking.
i wasn't.
early morning fog was in my eyes
and i could barely see two steps
in front of me.
but i saw her.
she was effortless,
walking as if the world was the sky
and she a weightless cloud.

it was a brief moment,
and i smiled,
for she seemed the opposite of me:
a dump truck filled to the top
with granite and debris.

we lie down against the
tall grains of an emerald,
meadow lake.
you wrap your
hand around my own as the world spins
beneath us,
we feel it – down deep in our souls.

time and space,
they twirl like twisted clouds,
so high above us now.

and here we are,
just you and me.

our love – the only sound.

Emerald Lake

MAGNIFICENT MESS

when fingers curl into fists,
we fight.
when torches are lit in the belly
of the night,
we prepare for something – more.

to stand up and say what is
and
isn't enough.

to be honest -
with ourselves.
that we can do better,
must be better,
with the time we have,
short as it may be.

to give and not want.

to stand and let sit
those that need rest.

to be a community
that realizes we are all
just people.

humans.
each a magnificent mess
until the very end.

gray rain seeps into my blood
like some kind of sweet tonic.
i can feel the darkness twitch, the
sorrow build, just under my skin,
and it's intoxicating.
if i'm honest, too many days of
heat and sun cripple the part of
my mind i love the most. there is
a heaviness that comes with a
cool damp rain that no amount
of sunshine can replace. i find
myself - my vision - when i
spend time in the shadows.
and i realize that may not make
much sense to some.

but, to those that it
does - cheers -
soak up that
gray rain.

gray rain

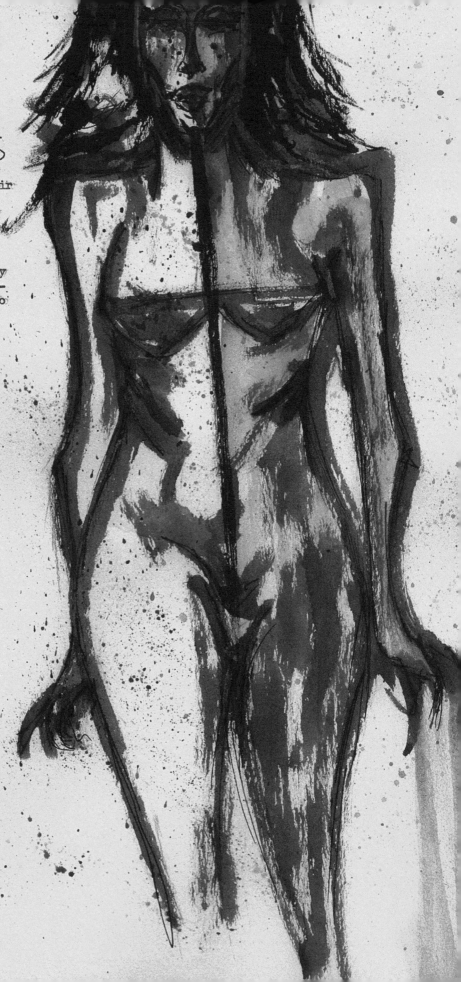

SHADOWS

some spend their
whole lives
worrying about
dark shadows,
but never me.

my shadow is my
greatest gift -
it allows me to
be free.

we are not the same-HOORAY

we, people of Earth, make a mistake when we look at someone we deem as happy and then alter our lives to reflect their patterns to achieve a similar level of happiness. it doesn't work like that.

first, who knows who is really happy? it could be a ruse. a whitewashing of an underlying canyon of sadness. second, people are different. no duh. but like way different. more different that we can possibly imagine. commercials want us to think we are all the same because, "hey i like sugar in my water too! i must be like you." nope. even people we identify with the most are so dissimilar from who we are at our core that if we took the time to think about it - go ahead - let's think about it for a second and come back.

ready? okay.

your best friend - she's just like you - except she loves running, like crazy loves it. wakes up at 5 in the morning to chase the sunrise. and you hate it. mornings are poison and shouldn't be consumed. but what do you do? you have a sad day.

a few sad days. and look at your friend's happiness that she gets from running and you want it. so you do all the things that she does. even with her. and alas, no happiness is found in the action. or at least no true joy. and this makes you more sad. defeated.

sucks right? we've all tried that formula and maybe it works and maybe it doesn't. who's to say? i am not against trying new things to find a new level of happiness, i am just saying that it's a good thing to be different. even from the people we admire. maybe especially.

"what is the point?"

good question. and i never promised an answer.
i will end with this:

happiness isn't found by mirroring others. their actions. commitments.

happiness is found by embracing our reflection in the mirror. understanding that what we are is flawed and perfect. and no matter how much we feel like we are similar to someone else, we aren't.

that's awesome. you're awesome.

go be awesome.

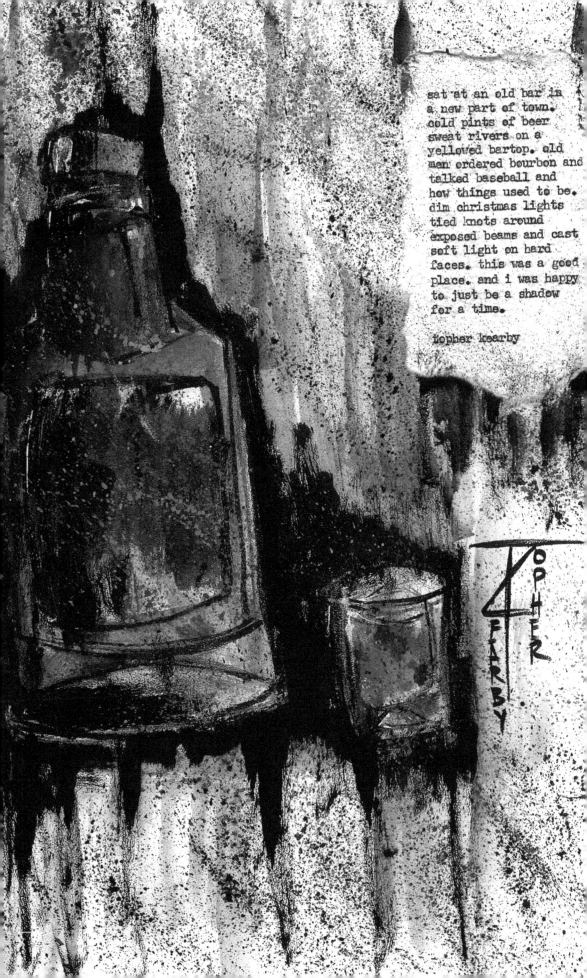

sat at an old bar in
a new part of town.
cold pints of beer
sweat rivers on a
yellowed bartop. old
men ordered bourbon and
talked baseball and
how things used to be.
dim christmas lights
tied knots around
exposed beams and cast
soft light on hard
faces. this was a good
place. and i was happy
to just be a shadow
for a time.

topher kearby

bury me deep,
they better,

far, far deeper
than they
normally do,

for i've spent
my whole life
fighting
and sparring,

and no heaven
or hell is going to
keep me from
loving you.

ode to Cash

spent my life in the front
of a long truck

- Mac -

miles against rain and snow
hills and valleys
driving
moving here and there
working
paying the bills
kept my one and only
a happy home
never had a reason to pray

until that day you called
and said it'd spread
six months was all
you had left

so i stopped on I-70
and stepped into the rain
and asked god for a favor
i didn't earn

"take what breaths i still have left,
and give them to her."

favor

victory

standing on the bodies
of all that stood in our way –
knocking them down
one by one
as we climb into the heavens
reaching and clawing
for what is ours
feet pressed against cheekbones –
snapping and breaking

it's okay
we are fighting to be first
be best among the rest
of others
breaking eggs to make something
of ourselves
kicking them down
so we can stand high atop
the dreams of the small

you can't have what i want –
even if it's the only
thing you need

victory tastes like
poison

Bathroom Reflection

do you ever feel
that the reflection
in the bathroom
mirror has become
the real you
and the flesh and
bones standing in
front of it has
become just a
reflection of the
mirrored image?

EXQUISITE

hurt was always part of the plan.
pain?
the microscopic letters at the bottom
of the contract.
we signed it once we agreed to
breathe.

and yes, it's damn hard to just keep
moving some days.
easier to just cover up and hide.
chemicals in our heads
and events out of our control,
each driving us
a little more mad.

but breathe.
see?
we still can.

that's something.
and it's enough,
to turn that contract filled
with hurt
into something exquisite.

this life,
this pain,
this hope,
is ours.

the man attacked his brown paper bag
with an eerie anger.
i could feel it -
the caged energy boiling just under
his tailored suit.

this was breakfast -
not quite 7:30
and already he was looking for a fight.
with what?
with whom?
how am i to say? but he made me nervous.
the way he ripped his sandwich
from the bag,
tore it open,
and crushed the wrapper as if it
were somehow to blame for a wasted life.

i'm making too much of it
surely.
it was just breakfast
and he just a man needing coffee.

but for some reason
i worry
that it was more.

airport

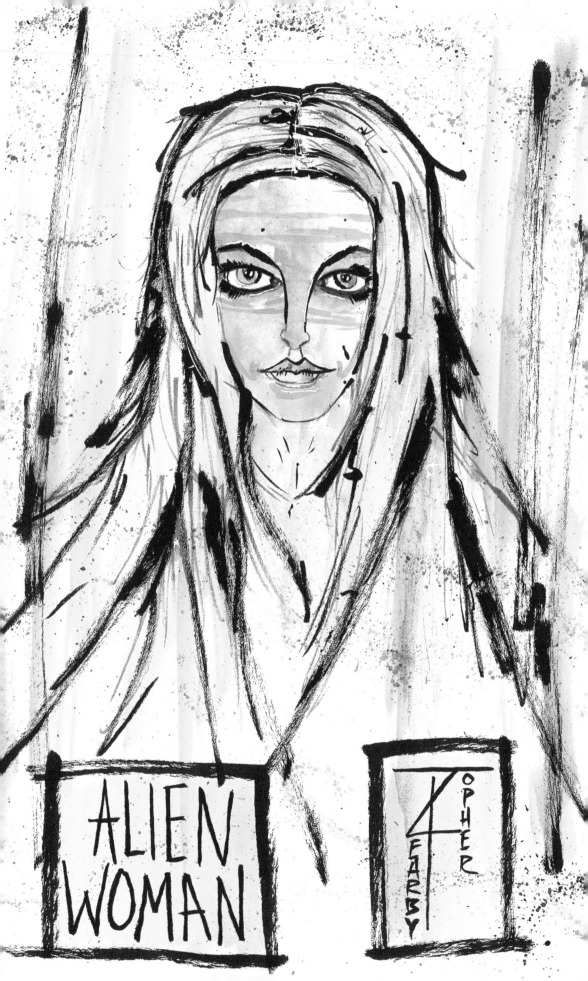

ALIEN WOMAN

some say we are
stardust
fallen from the
heavens like grains
of sand
so i wonder
perhaps i dream
if those we feel
the closest to are
part of the same
star

STARDUST

in the deep

dove fast into a too-full lake.
breath was taken first by the
cold and second by the thick
water my throat sucked down.
didn't gauge the depth before
i leaped.
could have died down
in the deep.
but that's just
who i am and who i'll be.

someone who rarely looks
before he leaps.

I
AM
A
PROUD
FAILURE

frozen time

i find myself often lost,
in moments
in time.
frozen.
as if the world
around me has been drenched
in thick syrup.
and i
- still aware -
am trapped,
just watching and thinking
about too much of everything.
it's strange because i know
i'm not the only one stuck
viewing the stalled world,
each of us locked in our own
mind like some sort of
pondering prisoner.
what if this...?
how could that...?
millions of questions to
answer in the shortest of
times.
the rest of this world sits
almost waiting for replies,
but i am not sure
the answers will ever come.
just more questions without
more time.

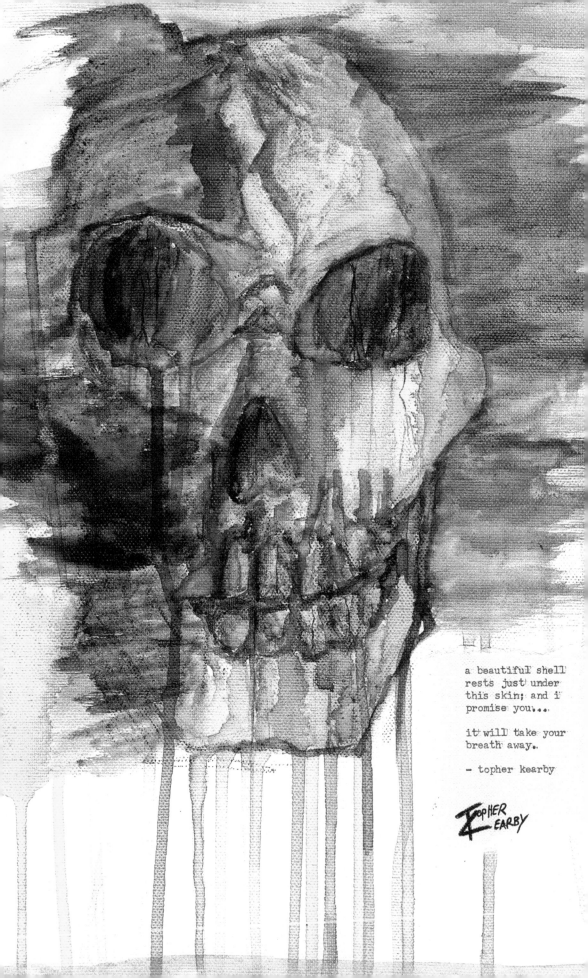

a beautiful shell
rests just under
this skin; and i
promise you...

it will take your
breath away.

- topher kearby

war called love

plastic bags filled with
worn out
tossed out
love
litter the asphalt.

shrapnel of splintered relationships
scar the countless faces
of the solemn citizens passing by.

clearly, all have been through
this
war
called
love.

lucky they are to still be
standing.

some days we are desperate
to be
invisible.
other times we ache
to be
seen.

it's part of this complicated
mystery called
being human.

invisible human

THERE ARE THOSE WHO MAKE.

AND THOSE WHO TAKE FROM THOSE WHO MAKE.

BE A MAKER.

stood still and skipped a smooth stone

then another

the water did what it was supposed

to do

- it shook -

a little with each hop

making the world blur

better that way

can't stand the clear

don't trust solid reflections

seem to be hiding something

images so pure

shadows tell better truths

or at least more interesting

stories

- another rock -

this one sank

too heavy

or too round

either way

i hope it found its place

at the bottom of the belly of the stream

HEAVY STONES

guest called HATE

hate is a cheating bastard of a guest.
invite it in and watch it contort
and twist
your vision until your eyes shrivel,
and the world dims dark.

bile in the belly, it'll make you sick -
hate.

comforting at first, but let it settle
and observe how it ruins and wrecks.

oh, hate, you putrid sack of lies.
weighing us down and keeping the rungs
on the upward ladder slick with crude oil.

give in and it goes to work calcifying
the tender pieces of your soul.

oh, hate,
you uninvited thief,
stay behind the locked latched door
and let us be.

the best you can do
is no more or less than the best
you can do.
you can be everything you are,
and nothing more.

if you feel that limits you,
then look harder at your
beautiful reflection.
embrace the strength
that sails the rivers and rapids
of your soul.

if you think that raises you too high,
you are, and excuse me for my bluntness,
terribly horribly wrong.
for never has there ever been a better you
than the you that you already are.

"but..."

but nothing at all.
we all have pasts,
and thankfully futures –
no matter how short.

so use every moment to be no more
or less
than
you.

the best you are

let them talk.
let them hate,
let them rage against what
they cannot change,

we will love.
we will find our peace.
we will do what we must
to make the world a
better place.

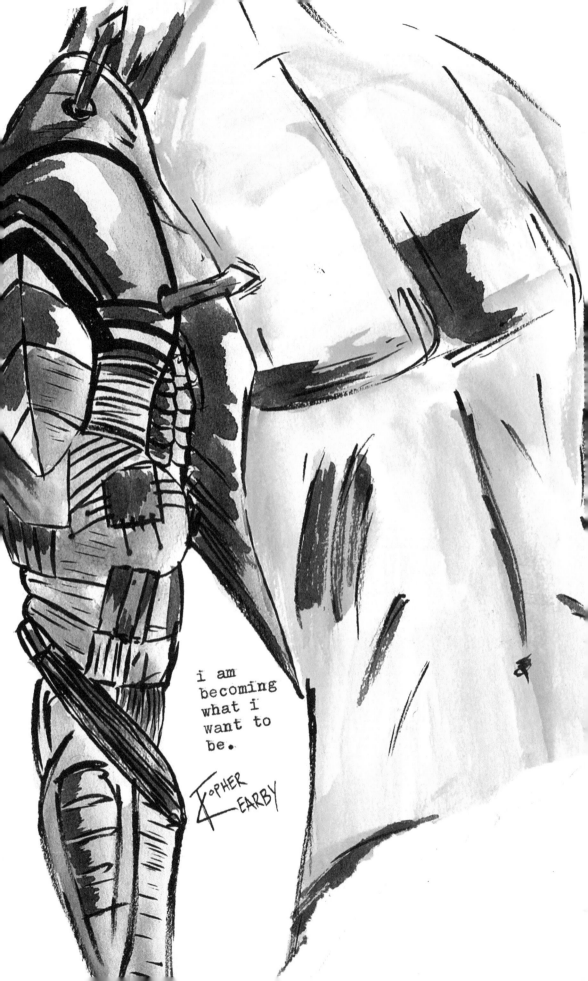

i am
becoming
what i
want to
be.

it was the grind that killed him,
the steady, throbbing pain of
never quite being enough of anything
to really be much of anything in this
world of almost nothing.

the weight of it all crushed him.
as a clinched palm might crack
an unboiled egg.
whatever man he once was is now
just spilt yolk on stained carpet.
he expected too much and got little.
common.
"idiots are the only happy ones,"
his father often spat.
and those were the kindest words
he ever uttered to his only son.

JUST A MAN

sit and think

and fret.

my mind is a maze of joy

and discontent;

glad to be here,

yet worried about the future,

paralyzed by the weight

of a life yet lived.

common feelings

wake me at night;

it's the human condition,

each of us hoping to be glad

with what we have, and still

be working toward a better

tomorrow.

sit and think

and fret.

my mind is a maze of hope

and dread.

HUMAN CONDITION

the empty scares most people -
THE VOID:
lack of anything other than
nothingness.

noise and pulse, they crave.
the intoxication of
activities.
those that run from
quiet.

my only guess is they've
never loved in a way
that strips the earth
of its starry gown,
and causes the universe
to shatter like
brittle glass.

because when you've felt
such love,
the powerful echoing
silence of two souls
colliding
to become one…

you never crave
anything
else.

void

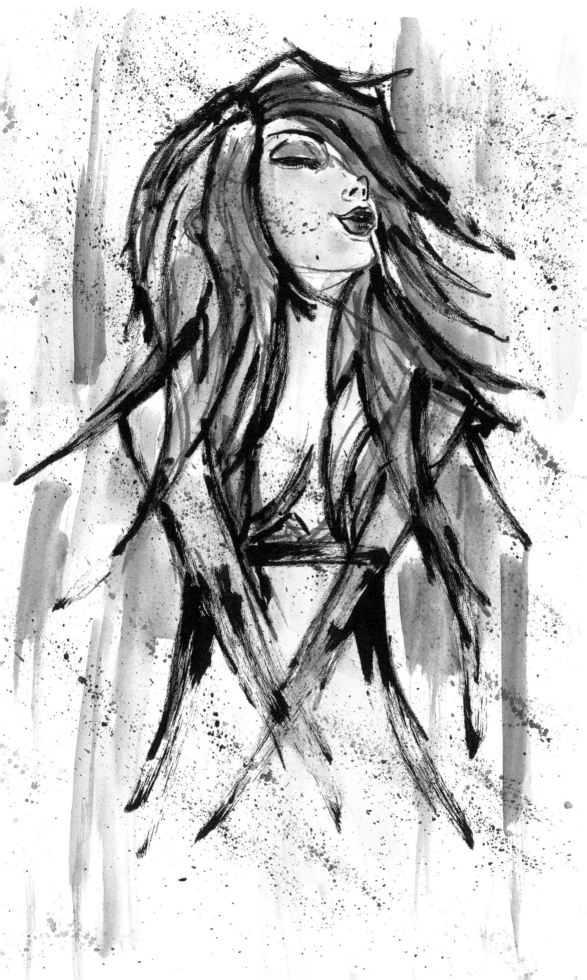

SOME SURVIVE

love is an island
amidst an endless
ocean of time.

we are each tossed into the
waves and told
to swim;
not how to swim
or why to swim
just to swim.

some drown.

water fills their lungs
and weighs them down
until their bodies
sink toward the belly
of the salt water
canyon.

some survive.

and perhaps find what they
were looking for.
perhaps.

love is an island.
and we were all just tossed
to sea.

i remember the way we kissed

well we never kissed

even though my mind saw the act a

thousand times

in a thousand ways

on a thousand days last june

they were good those kisses

shame you missed them

too busy being everything wonderful

you've ever been

which has never been anything more

than a daydream to me

and my thousand kisses

on those perfect thousand days

last june

fiction in june

seasons of us

together, we walked through
a sea of orange and red,
autumn leaves surrounded us.
shared easy laughs -
the kind you can't force
and talked about dreams and
how we saw our futures.

winter came, as it always does,
and we both became so cold.
so we took refuge there
to fight the chill
wrapped tightly in each other's arms.

but we both knew that
season wasn't ours.

grass turned green and flowers bloomed
and we drifted far apart.
for what we had amidst those
winter winds was the wrong
shade of love from our hearts.

now the summer sun,
it warms us both
and we can see each other's smile.
happy we are now,
in this place -
content to not be too close,
but still not very far.

happiness was us
when you and i were one
at least that's what i think of
when i think of happiness

it's been so long –
i know
but surely if you look back
in the back – way back corners
of your mind

surely
i am there with you
and you are happy

maybe though it's been too many
days
we've grown a bit - old
weather turned a bit - cold
our hearts have been bought and
- sold -
too many times
(many times too many)
i know

but still
the happiness i had with you
is still the only happiness
i've ever truly known

HAPPINESS

Tents and Jeff

something about me.

for the handful of people interested.

i'm confident. not in my skill at any particular task.

but in my ability to figure things out. put me in a forest

and i'll prop some sticks up and tape leaves together

in order to survive for a time.

(survival experts laugh hysterically.)

same is true for most avenues of my life. maybe it's a

strength. maybe a weakness. but i'll throw myself into

a situation fully trusting that i can learn as i go.

"sounds stupid. you're stupid, Topher," said Jeff.

sure. hasn't always worked out.

no need to get personal, Jeff.

i've made plenty of mistakes. i like mistakes.

that means i'm pushing myself. and the older i get

the more willing i am to fall on my face if needed.

one life. one chance to make an utter fool out of

myself pursuing what i love. i'm not going to waste

that opportunity worrying about jerks like Jeff.

"hey, man. that hurts."

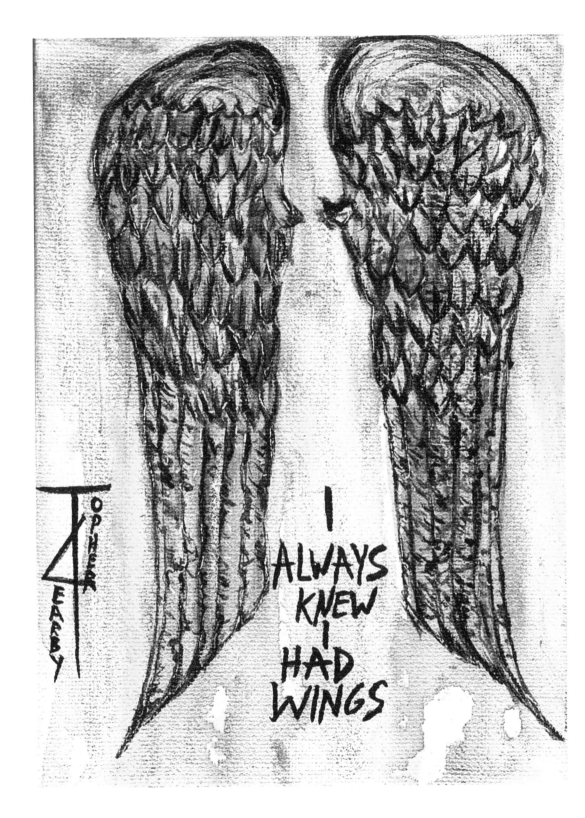

"are you sad?"

no. not really.

"but you seem sad. distant."

i'm just thinking.

"i wish you would share more. you know i'm here."

i can't explain my mind. it's just slush.

"i don't understand. are you depressed?"

i didn't ask you to understand. it's just how i get sometimes.

"how?"

more introspective than depressed.

"i'm not sure i can do this anymore. deal with this."

you mean deal with me?

"yes."

i get it. i'm difficult to know. i wouldn't blame you.

"so that's it?"

what?

"were you even listening?"

sorry. i was thinking.

Fair Enough, Stephen King

i dreamt last night that i met

Stephen King at a book signing

or some other type of show. he

was asleep at his table

so i woke him. gently.

"psst. wake up."

he thanked me

and signed a piece of my art.

i asked if i gave him my books

would he read them.

he touched my hand and said,

"no. no. i don't have time to waste."

fair enough, Stephen King.

fair enough.

in the morning time
just past a night of clouded dreams
i step outside

and breathe in the freshness
of a newly born breeze

and feel the coolness of
a freshly made rain
dance across my waking skin

perfect this moment
as the sun's rays kiss the sky

everything feels possible

i am
fully
alive

morning air

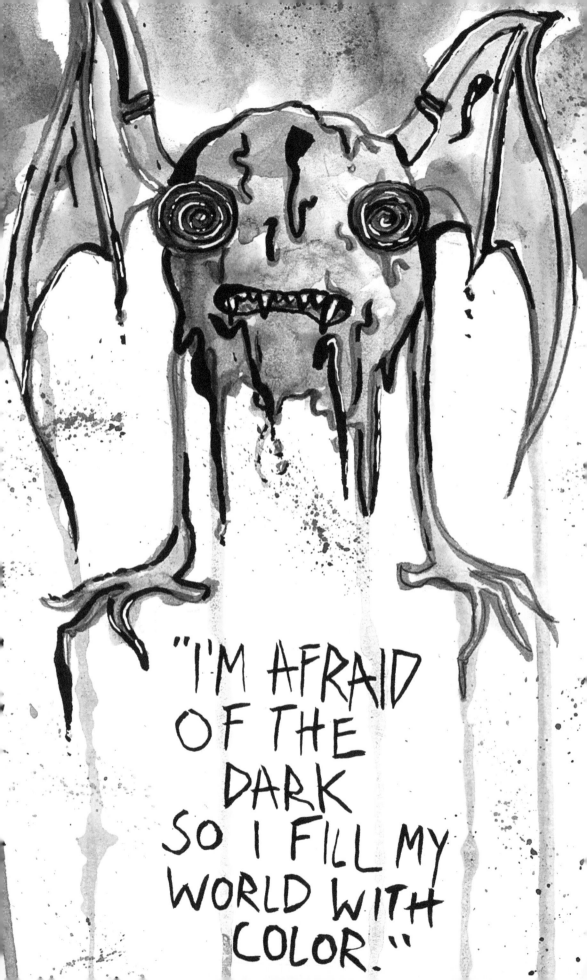

friends and lovers

old and new;

okay you want to be with me.

now what do i do?

i've gotten so good

at being just me.

not so much when it's

two or three.

so i push and i run

until all others

are far away.

hoping that where

i left them

is where they each will stay.

it's terrible.

it's true.

although i tried my hardest

it seems

i've done the same

to you.

PUSH

the man said

i'll give you anything

i just need your soul

i nodded

what did i have to lose

and scribbled my name on the line

so he took it and gave me what he promised

fortune and all the rest two boats press kits

gigs and a few wrapped baskets

all eyes on me

i did enjoy it

my few moments in the sun

then it came time to pass on

and as old men do i slipped into regret

that dotted line he had me sign

oh so long ago

gave him the only thing

that was ever really mine

Fortune

old man sits on a rickety rocker,

sipping iced tea

from a yellow plastic cup.

young man asks,

"any advice for someone like me?"

minute or two passes.

nothing said between the two.

old man finally stretches

and yawns.

"son, you gotta make friends

with the devils.

'cause they've been down your road

before. beware of all them angels.

not one of them ever put in an

honest day's work."

friends and angels

"yes, darlin', the night is falling fast, but hold me just a little while longer. for when the morning breaks I know you will be gone."

love falls fast

at first,

knocking you from

your feet.

pinning your body

against the ground.

then, it slows.

and drifts high

above you.

you reach,

and claw,

trying to pull

it down

but nothing can

be done.

love is the wind,

unable to be

controlled.

LOVE IS

dig deep into the belly
of a long lost love.

pull out those feelings
lost in the maze of your mind.
allow yourself to bask in
a past that was filled with
wonder.

live in that love for just
a little while longer,
then be done.

DIG DEEP

scream

he bottled his
rage
in his chest
like steam,

not until
his body was
six feet
under
could he finally

scream.

strength of love

some claim love is fragile;
touch it and watch it shatter.
but the love i've known has been able

to withstand far more than i'd
ever have guessed.

more prize-fighter than poet.
more Mac Truck than sunset.

think about it.
look back to your seventh grade
sweetheart.
still feel a bit
of that love after all this time?
or the most recent one that broke
your heart?
still a bit of love after what he put
you through?
see, love isn't so easily broken,
and it's almost impossible to
forget.
love,
maybe it's the strongest
thing of all.

MOVIES THAT YOU WATCH AT MIDNIGHT

i was watching The Matrix the other day. probably at midnight. great movie. and for the record the second and third are underrated. off topic but what movies do we get these days with that kind of strange philosophical depth and insane action? iron man 2? exactly. go re-watch them with an open mind.

waits ten hours

"i still hate the second two."

fair enough. at least you tried.

it's strange how much the first film gets right. creating a feeling that something isn't quite right in the normal world. it's an interesting idea. being plugged into a system. a system built to create happiness but in the end does the opposite. familiar?

think of the scenes where the cables are pulled out from the backs of the characters' necks. it's visceral.

painful. and then BOOM. welcome to the real world. this reality is dark and full of terrors. gritty and cold.

"here, eat this slime. it's probably not the worst thing ever."

(SPOILER) it's totally the worst thing ever.

but somehow that place of terribleness is where everything makes sense. life isn't supposed to be perfect. we aren't supposed to feel perfect. mornings often feel as though tubes are getting ripped out of our necks. and some days we just fight crazy robot squids until we pass out from exhaustion.

if we are lucky, we survive.

that's good enough. in fact, that's amazing.
the grit and grime of life is part of being fully human. the fight. the war with outside forces that want us to merely exist. to be fuel.

"how do we win?"

we recognize that tomorrow will be a fight just like today. winters will be cold. and summers hot. love feels amazing and pain feels horrible. that's life. that's us. that's a gift.

unplug.

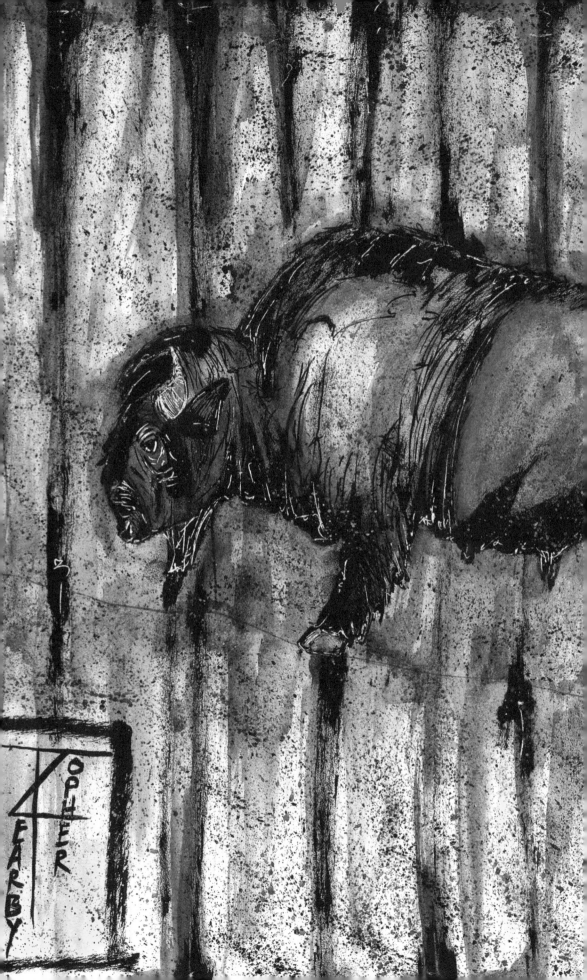

GIFT OF FIRE

fire rises above the horizon;
the sun's rays light
the sky.

mornings – how beautiful.

a chance to renew
tired spirits,
and wake
somnolent bones.

if we opened such a gift,
oh what magic we would feel.

so, let's treat
each new day
as such –
irreplaceable.
and accept the
daybreak fire,
and shed the many
heavy
layers of our soul.

yes, i am strong enough on
my own.
sure, i am happy enough on
my own.
true, i am successful enough
on my own.

but dammit,
i just don't want to be
on my own anymore.

complicated words

I've wasted so many
complicated words
trying to tell you
the simple truth.
I love you.
I need you.
I can't imagine my life
without you.

i am frustrated
most nights as i lie in bed
that i didn't get done
what needed to be done;
all those countless goals
in my head,
spinning like aluminum
windup toys.
each wound too tightly -
wobbling across an uneven table
until they fall to the floor.

i want to be better
each day
than i was the day before,
but it doesn't work like that;
life doesn't work like that.
some days you get worse.

and each morning i think it might
be the day where everything falls
into place.
and i become great.
at something – at one of these
pursuits i have worked so hard to
master.

night falls fast.
and i toss and turn,
waiting for a new chance
to start again.

I AM

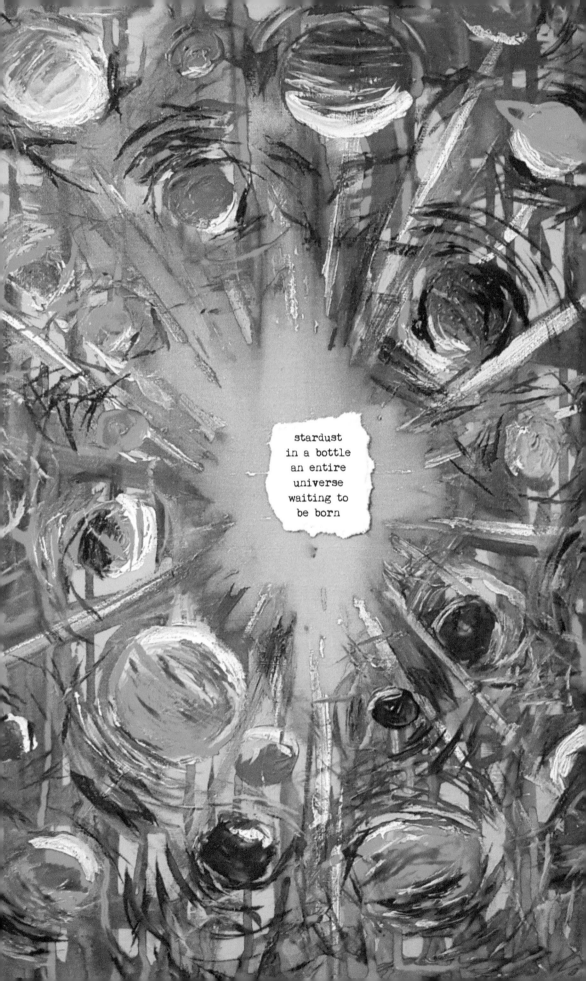

stardust
in a bottle
an entire
universe
waiting to
be born

i pull the checkered blanket
up just under your chin,
the way you like it,
because once again you've fallen
asleep on our couch.

our couch.
that's what we call it.

we found it on the curb somewhere
between our place and somewhere else.
took a bit of late night elbow grease
and a few shared bottles of stout
to clean it up.
but that's why it's ours –
it took time.

somehow this all means something:
you on our couch,
resting peacefully;
the one place you feel most safe.

i think that's love.
or at the very least,
our love personified.

OUR COUCH

sizzle.
steam.
coffee and cream.
skillet popping and
snapping.
morning rising.
orange fire lighting
the horizon.
heart beating.
palms sweating.
this is the day
our future begins.

sizzle.
steam.
fight for your
dreams.

we are each
human.
and we love
the best we
can.
if that isn't
enough for
someone,
then they
aren't enough
for you.

HUMAN LOVE

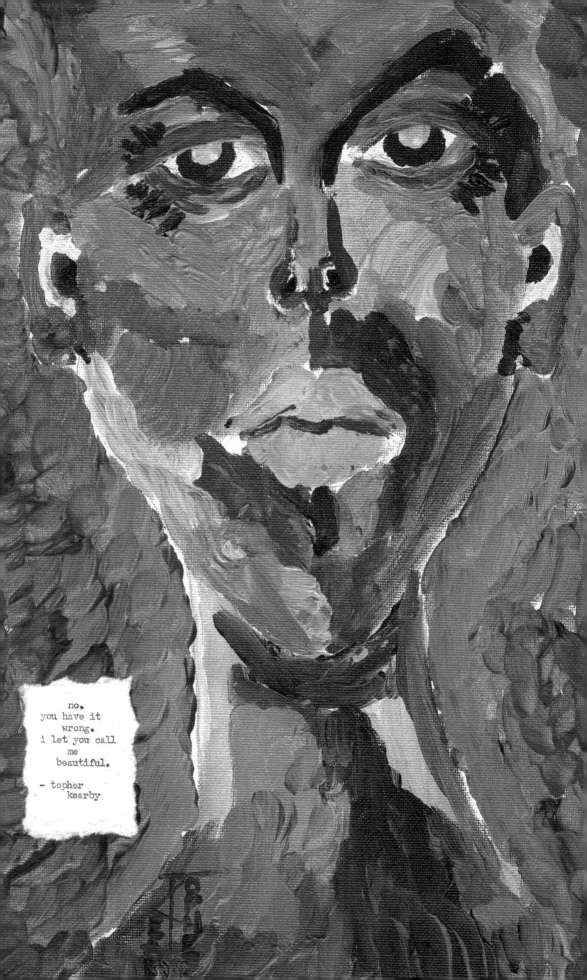

no.
you have it
wrong.
i let you call
me
beautiful.

- topher
 kearby

fall in love
during winter,
so you'll expect
the wind and
snow.

amongst the trees

when we walk amongst the
trees, and listen to the babble
of a passing stream, are we upset
that a tree has grown?
or that the waters move at a different pace?

no, for that is life in nature.
change. it doesn't bother us when
it's in the everyday things.
then why are we shocked when people
echo the same rhythm?

"you've changed."
i sure hope so.

"this is it for us," she said.
i nodded, sipped my coffee, and scratched
at the scruff on my neck. physically, we
sat inches away from each other,
in every other way we were miles apart.
"you gonna say something?" she asked.
"what's to say?" i watched her green eyes roll
and her thin arms cross her chest.
"you always do that."
"do what?"
"THAT!" she groaned. "you always answer my
question with another damn question."
fighting off a smile, i shrugged.
i did it because she hated it, and she hated it
because she hated me. it was okay.
feeling was shared.
i sipped my coffee a bit more, and tossed
a few bucks on the table.
"leaving? just like that?" she was standing
with her hands on her hips.
"without even saying goodbye?"
"am i?"
i could almost hear her fume as the diner door
swung closed behind me.
whatever was next wasn't with her,
and that was a good thing.

DINER

LOST FRIEND

wandering in the wilderness,
i stumbled and tripped
amongst the thorns.
amidst ancient trees
and forgotten paths,
i was lost.

my skin – tattered.
my spirit – torn.

then a new voice called to me,
tone as soft as the morning dew,
beckoning me to move forward,
to keep fighting,
to be made new.

a friend i found in the
darkest darkness,
a hand outstretched to mine.
together we make this
world seem bright.

a true friendship
for all time.

We aren't given enough skin to cover our fragile souls from this harsh world.

I MEASURE SUCCESS BY HOW MANY TIMES I'VE FAILED. THAT WAY I KNOW I'M GROWING.

broken mess

we were broken
each a mess
yet somehow
when we came
together
our pieces
finally
fit

HOLD ON TO NOTHING AND THAT'S EXACTLY WHAT YOU'LL KEEP

INFINITE

a love letter to space travel

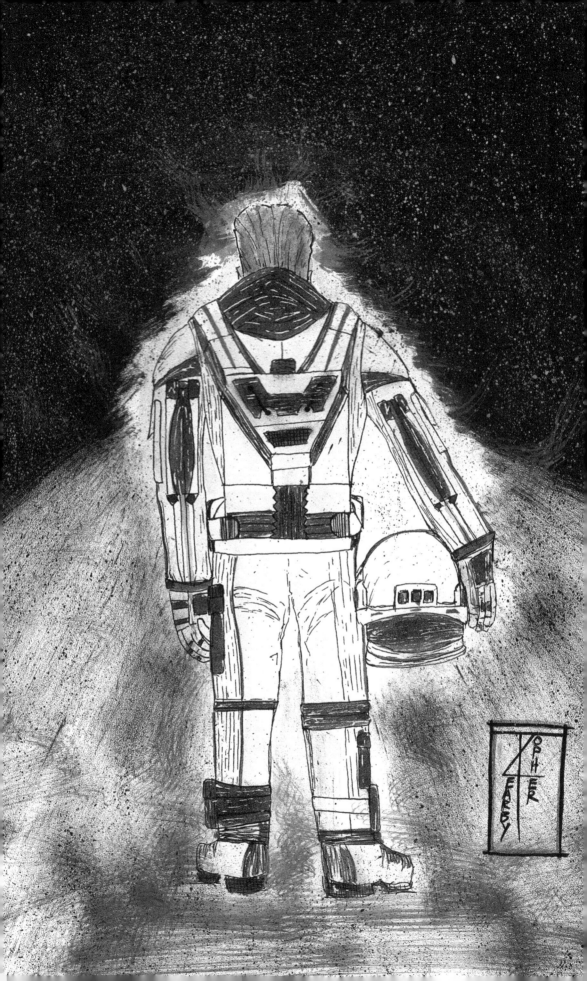

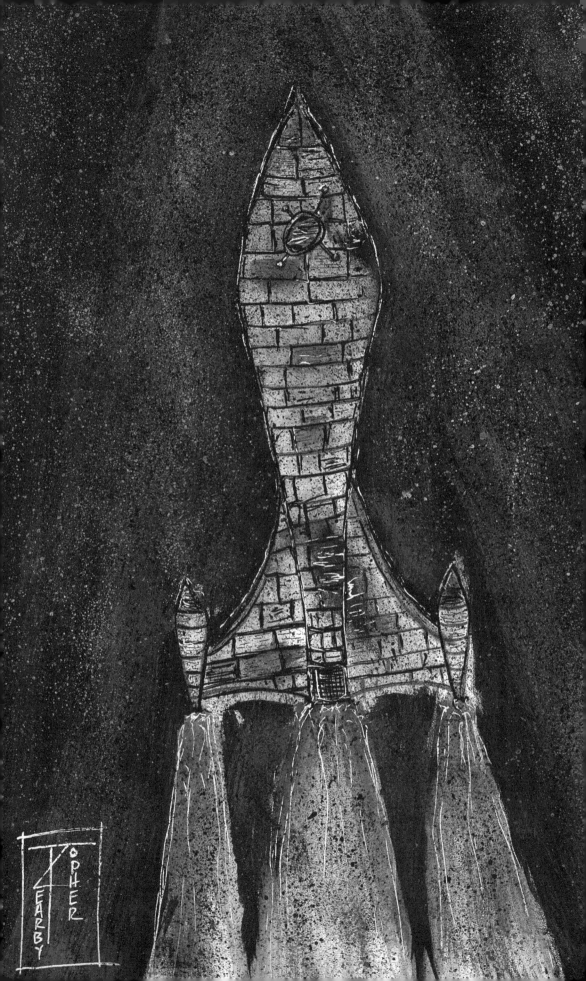

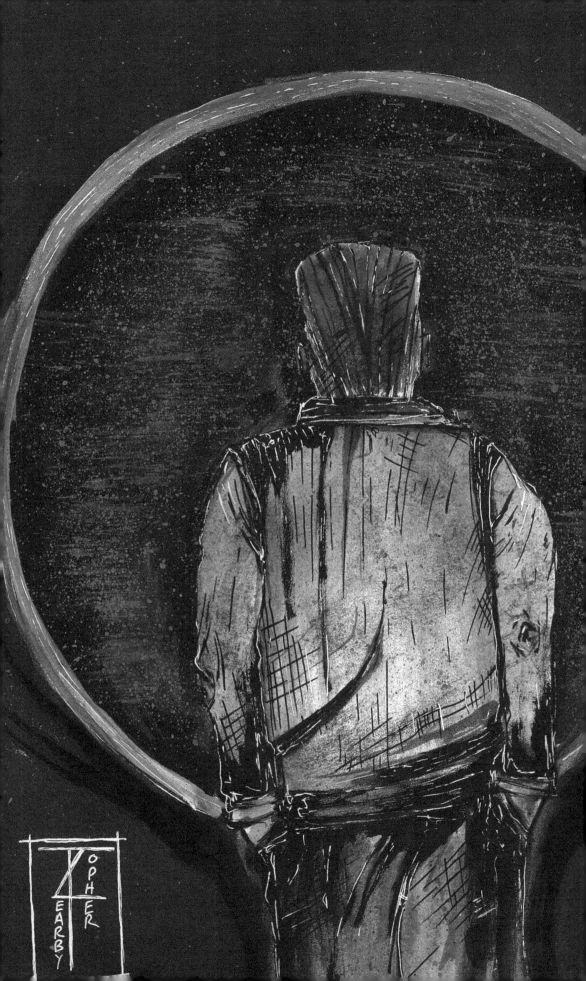

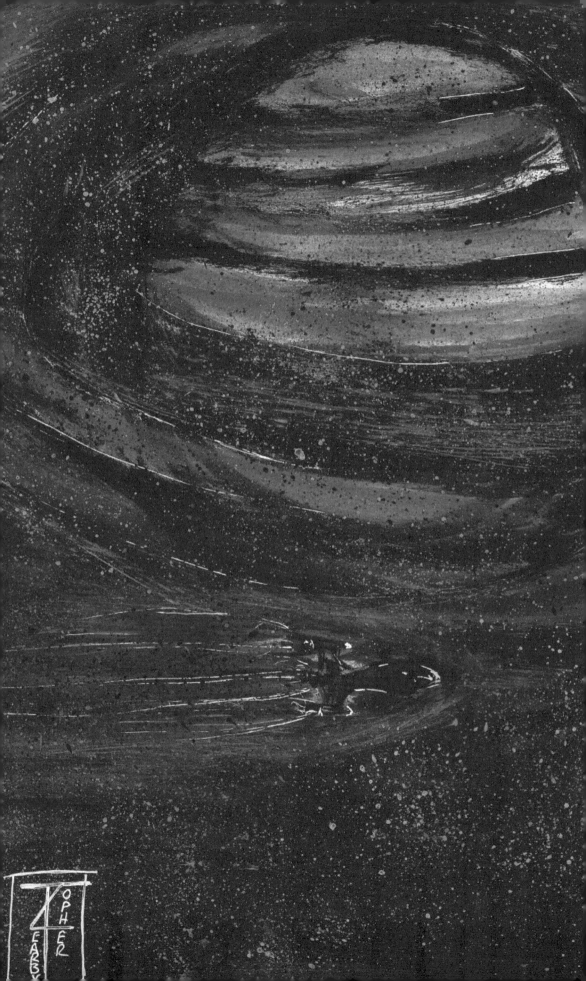

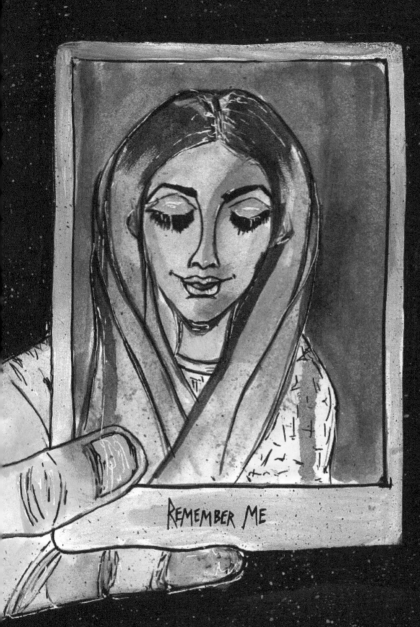

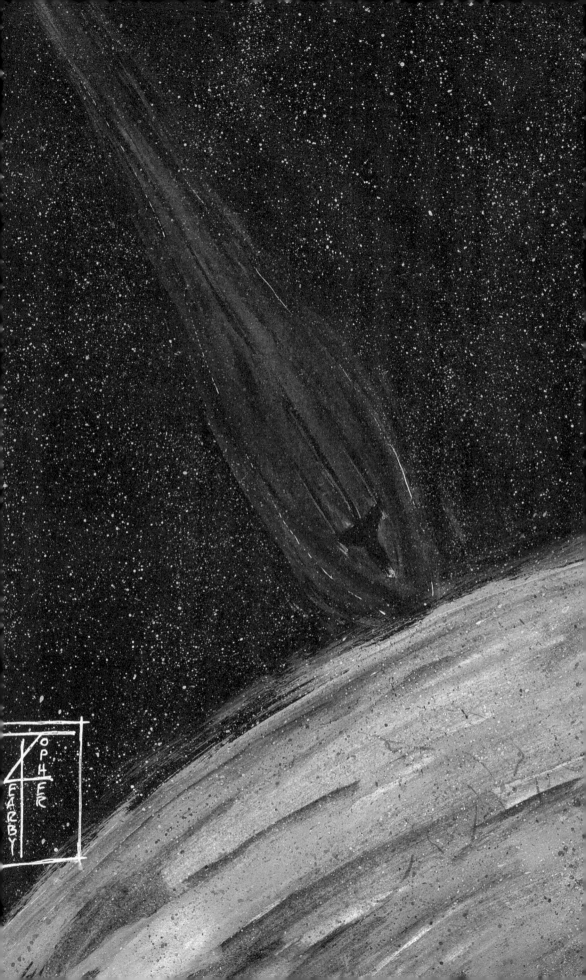

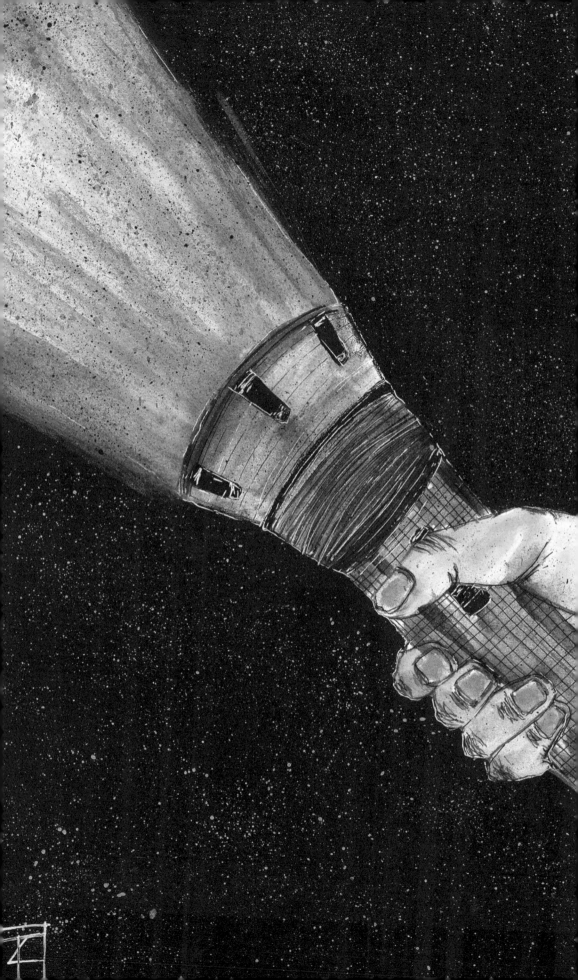

i shone my light
into the endless night and
what i saw brought me to
my knees.

my love,
my life,
my everything,
was scattered,
broken by the sea.

i would never go back.
i could never leave.

this place of darkness
had
taken
all
that
remained
of
me.

stars and fire

i thought i saw stars in her eyes
glimmering
shimmering
shining in the night

but i was wrong
it was fire

and those eyes
they turned my soul
to ash

The Last Kite

a young girl wraps a thin line of twine around her arm. over and over she spools the thread on her thin wrist as the wind whips strands of loose hair against her cheeks. a smile, so wide it could swallow the world, sits between a pair of rose-colored cheeks. if happiness were a picture it would be her on this day.

her father stands just behind her and looks up. black as coal and filled with fat gray clouds, the sky looks menacing. he can't help but shake his head in disgust. i can't believe it's come to this, he thinks. surely it was just days, no, hours ago, that his daughter was born and the world was a safe place - at least for her. now it's just the opposite.

the bright pink kite seems to shine against the dark sky. its purple tail twists and twirls in the turbulent wind. "look at it go, daddy," the girl squeals. "so high!" he has to remind himself to speak. words have been sticking in his throat lately, unable to escape. it's stress that is eating him from the inside and choking his voice. he's felt the gnawing relentless pain ever since he first heard the news. "you're doing great," he finally responds. "now run and take it higher."

the girl takes off across the field. her bare feet slip against the rocks and dirt that cover the ground, but the loose terrain doesn't slow her pace. "watch me," she squeals. soon she starts to spin in tight circles. her white dress twirls at her waist, floating higher with each turn she makes. "i'm flying!"

"don't fly too high," he says, smiling. though, his heart aches with that idea. most people paid to ride the air ships through the sky. he couldn't afford the fare. especially not for two. he'd sold every possession he had, which wasn't much in the end, just a collection of vintage records, some furniture, and the one thing he never thought he'd be without - his wedding ring. he rubs the bare skin where the ring used to sit. it still feels like it's there if he doesn't look. in many ways, it's the same for his wife. he shakes his head. not right now, he thinks.

"daddy, i said watch me," the girl says. she stands with one hand on her hip. "you promised."

he nods his head. "i am watching and i want you to run faster!"

the girl smiles. "here I go," she says, and takes off faster than before.

for a moment her father forgets his worries. he watches his daughter run up and down the rolling hills. each of her steps takes her farther. each of her breaths sends the kite higher, moving it closer to the dark sky. he's reminded of the first time he brought his daughter to this field. it was filled with tall grasses and wild flowers. he remembers his wife spending hours taking pictures of their baby girl amidst the ocean of color, making sure to capture each shot in the perfect light. that, of course, was before the sun went black; before everything changed. this isn't fair, he thinks, as he scans the gray landscape. none of this is fair. unaware of a past full of color, the girl gleefully sprints

and jumps and spins until her lungs burn and her legs ache. she stops and gulps mouthfuls of air until her breathing calms. looking up, she sees the pink fabric soaring high above her and smiles.

"she doesn't know," her father says aloud, "that the string wrapped around her wrist is attached to something so fleeting. how could she?" he hadn't told her about the giant rock falling from the sky. no one had - he'd made sure of that. she was his to protect and this time he wouldn't let anything happen. at least, not until the end.

once more she runs across the field and over the rolling hills until she jumps into her father's arms. her breaths are short and her heart beats fast inside her chest. "i'm thirsty," she says. "can i take a rest?"

"of course," he says, "take all the time you want. we have today to play." that much is true, though how much of the day is left he doesn't know. he squints and glares, trying to see beyond the ash-colored sky. it's no use. they, those that study and watch, have said that today is the day that the spinning burning rock will tear the sky and rip a hole so deep and wide in the ground that nothing will survive. the air feels different today - calmer. the ground feels more relaxed under his feet, as if prepared for something. he is neither calm nor relaxed. the unknown terrifies him.

"drink?" she asks.

"right," he says, snapping back to reality. "stay right here."

"run faster!" she giggles.

he can't help but laugh too. since she was born she's always been funny. all kids do funny things: tripping, mispronouncing words and such, but she had a different sense of humor - developed. he'd always said that she got it from her mother, and that was probably true. his wife laughed at anything and everything. she had that happy gene that some people are lucky to be born with. she soaked up whatever joy was left and gave it back to those around her with her laugh and smile. He missed that the most, especially on a day like today.

"here you go," he says, handing his daughter a bottle of water. "it's nice and cold."

the young girl takes a long drink and wipes her face.

"thank you, daddy." she squeezes her arms around her father. "this is the best day."

tears stream down the man's face. "you're welcome, my love. i wish i could do more." he looks up to see what his heart had been dreading for so long.

"the sky," the girl says, "it's beautiful."

he gathers his daughter in his arms and holds her tightly against his chest. "i love you," he whispers. "and always will."

drive

i drive in silence most of the time,
when i can.
no music or talkers,
just the rumble of my jeep's engine,
the rattle of the road,
and, if weather allows, the wind whipping
around my ears.
it wasn't always this way.
as the years pass i find myself
with less time to think.
i'm doing more.
each day something new is added to my
pile of projects.
but the moments i have to consider what is next,
or what i think about what has just been,
those are not many.
driving forces me to stop moving.
my mind, in this place, allows itself to rest
and i find myself thinking,
even talking aloud to myself,
about all the ideas i haven't had a chance to
dissect or examine.
and it's a beautiful thing -
this bit of roadway therapy.

Favorite Song

press your skin
so close to mine and
hear the tune of our
favorite song

two heartbeats
beating as one

New Love on You

you borrowed my love for a time,

tried it on to test its fit,

even matched it with the finest

diamonds and strings of pearls,

took it dancing with all the

other lovely girls.

but after some time my love

started to fade and age.

and your once soft heart became

quite hard and jaded.

and my once beautiful love?

well it just wouldn't do.

so you tried a new love on you.

be with me for just a moment
longer
let's outlast the fog of morning
break
push back all those dreams of
tomorrow
love with me here in this
quiet place
for pages turn
and tell new stories
flipping past so many beautiful
days
memories become blurs
in mere moments
weeks and years
they quickly fade
but you and i
will be forever
locked inside this
perfect day
because we both chose
not to turn our pages
you and me
we chose to stay

STAY

coffee

we sat and watched the sunrise
on our porch that
creaked and groaned.

the sky was highlighted with
shades of ginger and rose.
it almost looked fake,
as if someone had climbed
a soaring ladder
and dyed it while we slept.

hot coffee steamed
and plaid blankets warmed us.
the morning, as it does,
carried quite a chill.

i looked at you and nodded.
nothing needed to be spoken,

for life had given us this
perfect morning,
and words
would leave it broken.

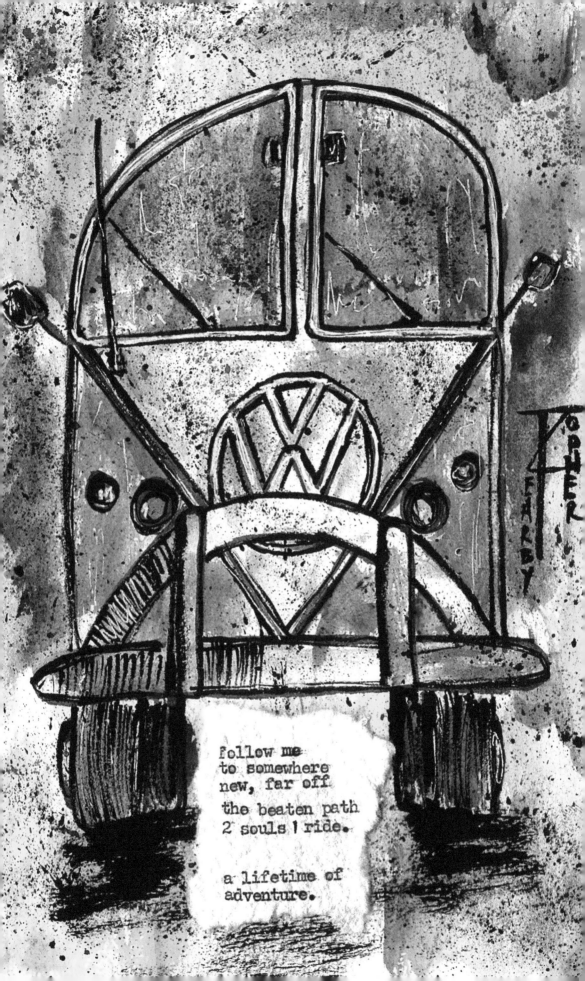

follow me
to somewhere
new, far off

the beaten path
2 souls 1 ride.

a lifetime of
adventure.

California to New York

drove from California to New York
logged my miles as i went
crashed at a few low-level motels on the way
interstates and highways
gas and go

days i spent traveling
all of them leading me to you

saw you
wearing a summer dress
and a winter scarf
books in hand
freckles on cheeks
beautiful in every way

forgot those miles
and that string of cheap sleep
when my lips finally
met yours
i was free

our love was a
beautiful
terrible
dream of a
nightmare
and i miss it
each time i
wake

TAKE HOLD

take hold of that someone who knows
that something
that no one else has ever known.
take hands and wrap fingers
while you step into the life
that was meant
for just the two of you.
hold tight that someone who felt that
something inside of you
that was hidden from the rest.
good.
it's better to not share
the best parts with the rest of the world.

hard times have built this love
days apart
nights spent alone and wanting
we chuckle together at the idea of
broken hearts
for we have weathered our share
and survived
challenges have been our sonnets
and we've read each line
over and over again
9-5 happiness and keeping up
with the Smiths
has never been for us
we wear our pain with pride
it's served us well
why toss it now

you can do this
keep fighting

our love letters

for life isn't easy
especially when you have to fight
for someone's love

Hard Love

I BOUGHT HER FLOWERS, NOT BECAUSE SHE NEEDED THEM, BUT BECAUSE I NEEDED HER.

COMPLICATE

we complicate love with
fiction and fantasy,
when at its core
is a simple truth:

we all want to be seen
for who we really are by
someone
who genuinely cares.

your ideas
do not
define me.

-topher
kearby

FIND SOMEONE WHO LOVES YOU FOR YOUR JEKYLL AND YOUR HYDE

the wilderness,
that's where you found me,
far outside of the roadways
of the ordinary.
i lived there, alone,
and never thought i needed
anything or anyone.

i was content in my solitude,
resolved that to live empty
was enough.
loneliness would die with me,
and I with it.
then,
you fought for me,
and proved that love
isn't broken or needy
or small.

and I no longer wanted
to be lost.

found me

when i close my eyes, i
see you;
vivid images of the past.
auburn curls
and blue jean cutoffs.
a bright smile - always.
in honest moments
i miss you.
and i wonder what i did
to lose you.
too much of me
is too much for most.
i guess that happened
to us.

in truth,
i'd probably leave me if
i could.

i am not a social butterfly,
fluttering around events and parties
adding color to the scene.

i am a solitary moth,
drawn to the dark places where i
can be alone and think.

i lived a lifetime
in a moment
on the edges of your lips.

the future was suddenly
realized
the day we first kissed.

time stood on end,
and the world froze;
for once my mind was still.

and it was flawless,
and it was everything,
in that one moment
so quick.

HEAVY IS THE MIND OF A LOVER, ADRIFT IN THE ENDLESS SEA OF NIGHT.

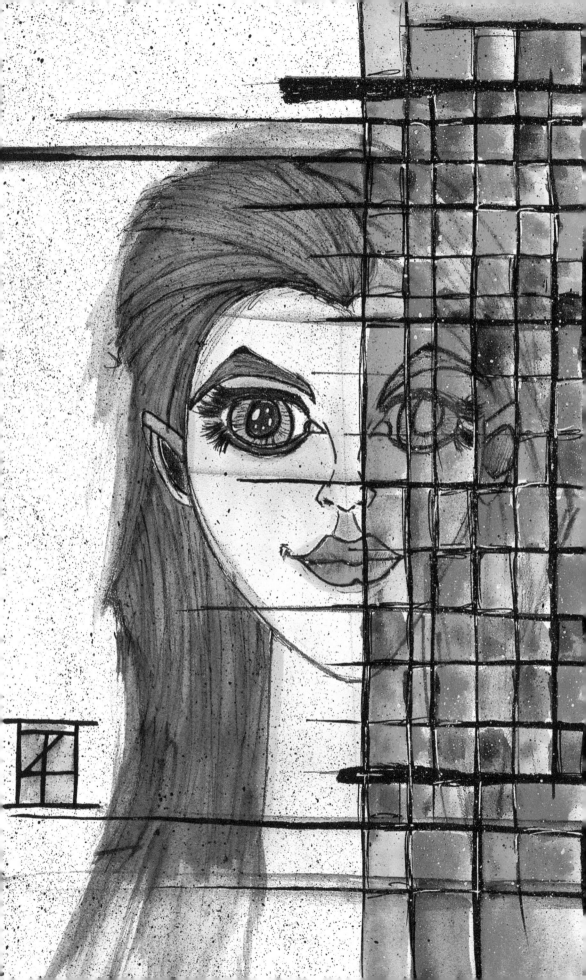

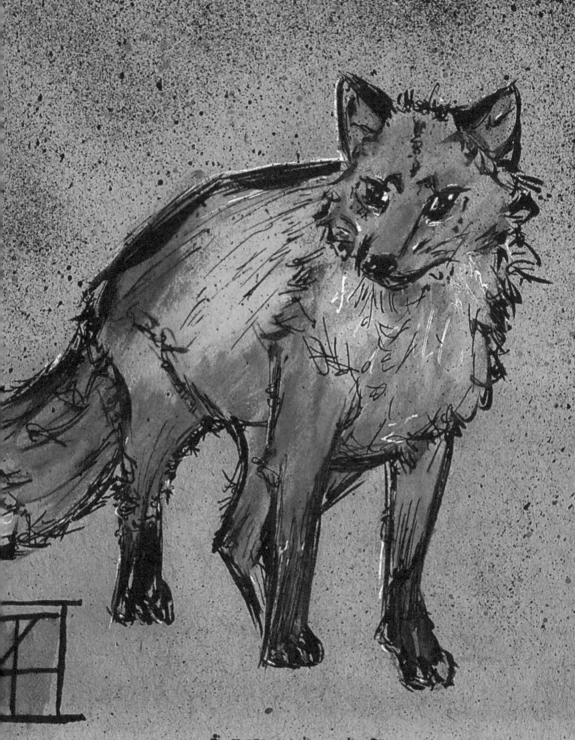

i never trusted
that ol' fox,
but i kept letting
him in to play.

topher kearby.

like the perfect song on the radio
makes you keep driving
long past whatever turn you
meant to take,
your mind is
locked in a perfect trance
of happiness and something else
altogether.

that bit of time - lost.
isn't it great when love is
like that?
hours fade away and
turns are missed.
maybe that's real joy
- that love -
lost in the moment
with another on your mind.
just for a bit of time.

how perfect.
how pure.

"i'm terrified," she said.
looking ahead to her future.

a gentle smile covered the
old man's face.
"then you're in the right place."

the sun cried out
to the moon,
"lie with me for
a while."

the moon's heart
broke, for he knew
he could not.
it was his destiny
to light the night's sky.

Ships and Paths

we built two ships,
each near the same weight and size,
and sailed them to opposite
ends of the world.

we were done with each other and
agreed to part ways,
neither knowing where the other
planned to travel.

the waves rocked, as they do, and
the winds howled.
i lost my course more than once. but
in the end i arrived unharmed.

and to my surprise,
you were there too.

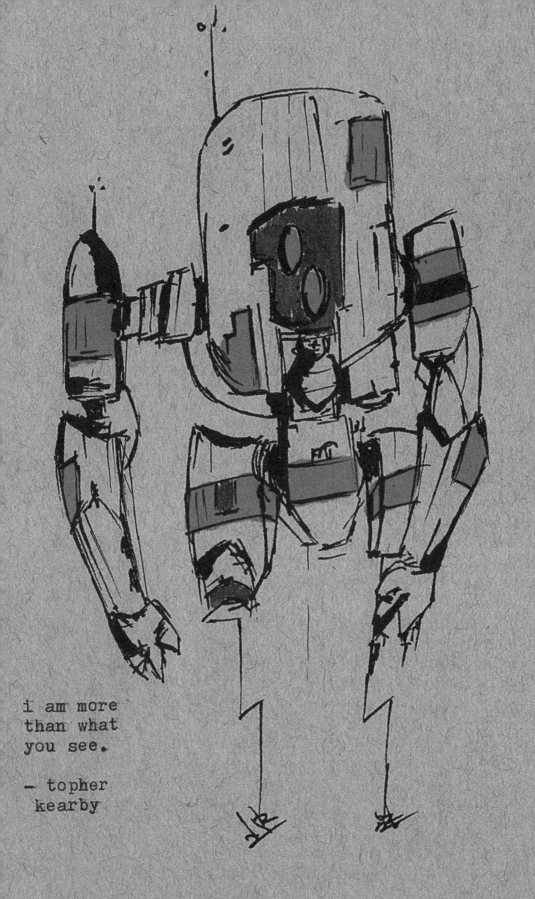

i am more
than what
you see.

— topher
 kearby

THINLY

you loved me thinly,
as if the slightest
breeze could blow you
off my course.
it's difficult to love and
be loved like that,
always mending sails
instead of moving
forward.

it's better to love heavily,
with red bricks
built to weather
and last.

it's an impossible task to put your heart on sale.

customers always have complaints.

FEED THE BEAST

in the belly of the beast
my soul searches for something
to eat,
to consume,
to feed a never-dying need
to be
the beast.

what claws it has,
sharp and twisted.

its fangs,
how sharp
they sink into my tender
flesh
and rip apart
the hidden secrets
buried in the darkest corners of
my fragile mind

until i feed it
- the starving beast -
with what it greedily craves.

then and only then

does it
finally
let me
be.

SLOW

taking slow steps
across a quick creek
letting days pass across the shallow
waters
like hours and minutes
finish and begin it
a trip down a paused reality
so precious
can never forget this
moment
alone gathering thoughts hidden
forbidden concepts
doing nothing
wasting slow breaths
on nothing more than selfishness
pause
let the silence refresh
everything this world's spent
crickets creak and streams bend
without these moments
surely my life would end
in brokenness
worn down weariness
back burdened by the weight of a
perfectionist
breathe
soak up the short rest
respite
letting gloves retire from a long
fight
peace
in a place of unfamiliar quiet

we walked together on the

edges of faded stars.

midnight mornings were our

playgrounds.

the last glow of the evening

moon always tucked us in each

morning,

as we fell asleep laughing

about our shared mistakes.

and now

the morning sun just

rises.

and we share no secrets

with the moon.

FADED STARS

clink
clank
crack
crash

the sounds of a heart shattering
into infinite pieces
against cold concrete

tossed aside like ordinary
glassware
only to be swept up
and taken out with
the trash

Garbage Heart

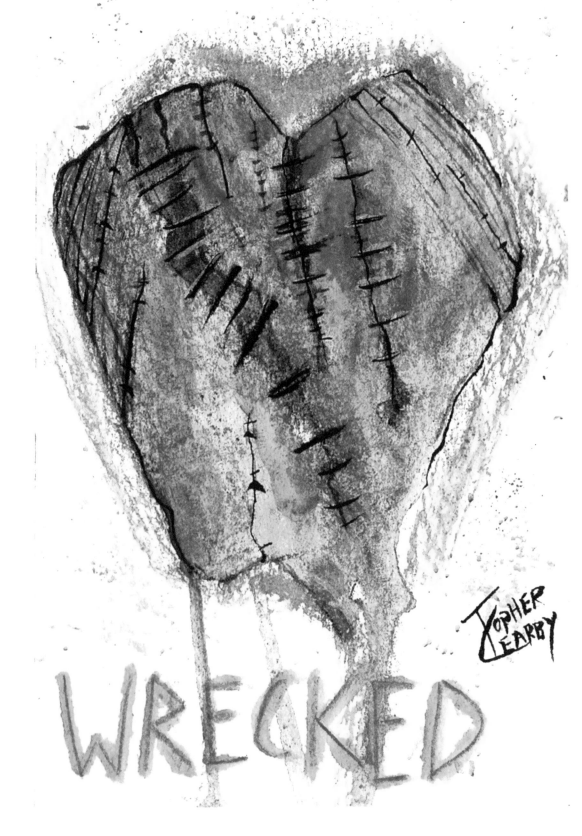

i pulled out my
old heart
and buried it
deep
underground.

but every time
i think of you
i still hear that
pulsing sound.

we built a wall

with each word
we spoke
with each insult
we spat

higher and higher
until neither could
see the top

and we lived
separated

then one day
the winds blew
and the rain fell
and that tall wall
we built
crumbled
to the ground

and there amidst the
storm we saw each other
again
how we once did

as lovers
as friends

Crumbled

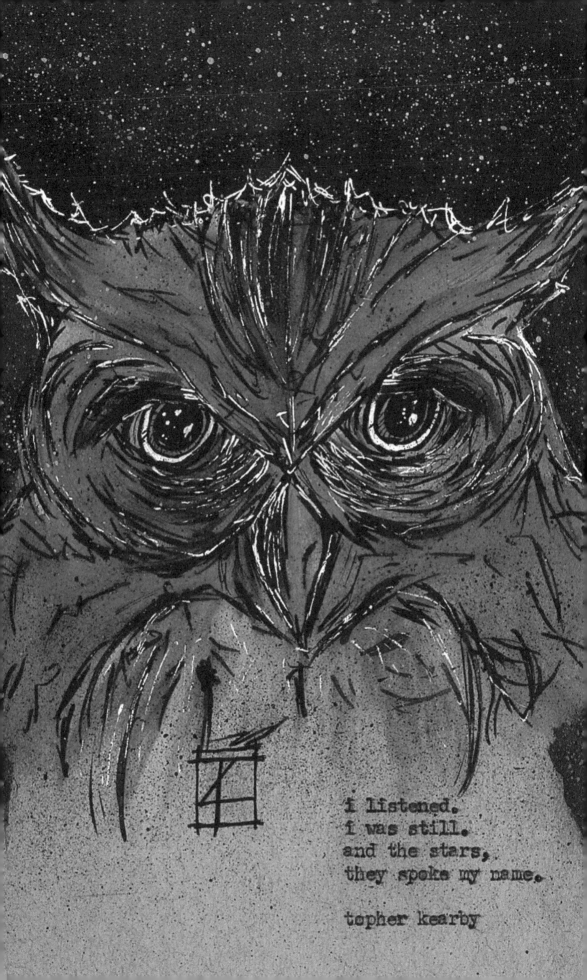

i listened.
i was still.
and the stars,
they spoke my name.

topher kearby

"i have a few regrets," said the old man,
as his love gripped his hand.
"maybe just one or two. and each of them
was on a day i didn't spend with you."

a bit of heart

hold a bit of heart in your hand
sweat a little
as it beats against your skin
fingers
let them trace the veins
feel the pulse of what moves so
many mountains
causes so many wars
boils blood
and crashes ships against
so many shores

only in this way can you know

what you
take
when you
break

a beating
loving
heart

we ate Froot Loops and drank
bad coffee, laughing between
the sips.

it had been a good
night together, and this lame
morning routine was one we
loved.

"keep it simple," you'd say.
and i'd open the curtains
so we could watch the sunrise.

lame mornings together,
funny how those are the ones
i miss the most.

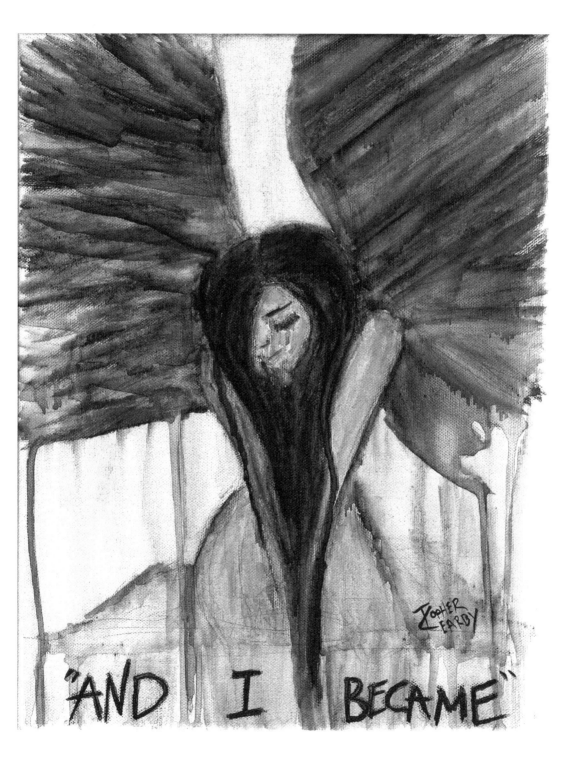

you were once

an unknown
- uninvited -
guest in my
life.

but now
i can't

imagine
what i'd be
with you
gone.

UNINVITED

FIRE & SLAG

there are times when fire sits on
my lips,
and i can't help but burn with my
mouth.
hasty kisses and rusted daggers
for words.

i harm.
i fail.

my lungs fill with slag and wet
concrete
until i can no longer breathe or
move from the weight.

and i become less,

become human.

fire and slag.
scorch and weight.
i harm.

"i am tired,"
the old man said,
shutting his eyes for the final time,
"and i've earned this sleep."

rivers, they call to me from a distance.

unknown voices
echo across the blue waters
and white-tipped rapids.

"step in and be washed away."

and i listen
and i wonder
what might be if i dunked my head
and soaked my bones
and drank the crystal clear
until i could only see the haze.

cool waters, they beckon
quick streams, they call
fast rapids, they sing to me.

"drown yourself and be lost."

SIREN RIVER

tomorrow is a new day
there will be time
spinning rubber tires
there will be time
hurry hurry rush run
faster daughter
come on son
day is setting
morning breaks
wasting time
must never wait
there will be time
what's now can pause for what is next
picked the roses to stop and smell
threw them in the backseat
no time for breakfast
no time for me
no time for anything
can't you see
not right now
at least
but maybe
one day
there will be time

there will be time

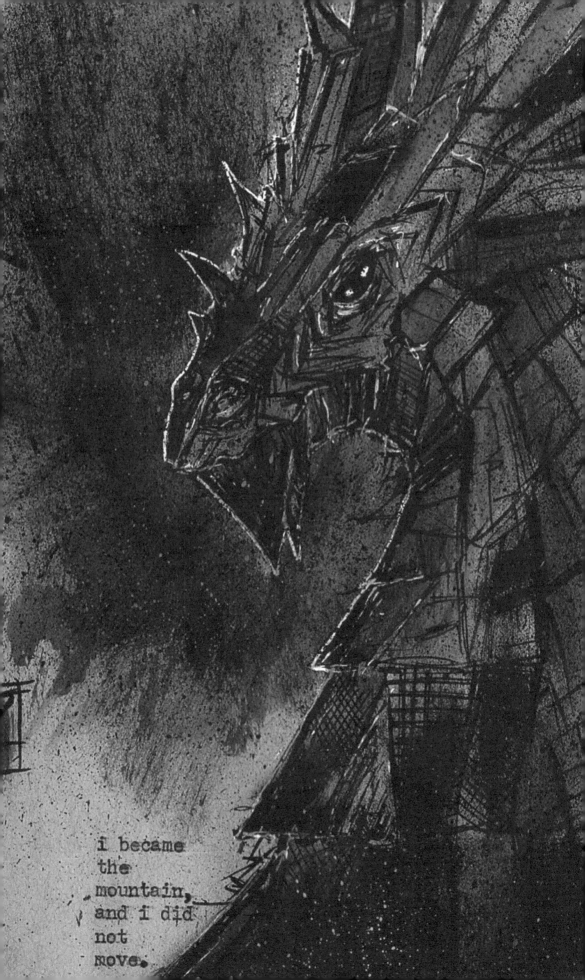

i became
the
mountain,
and i did
not
move.

rain, cold rain,
has a way of soaking
dry bones,
seeping down deep as if it were blood,
circulating and touching every inch
of a warm body.

parasite?
or welcomed guest?

either way it doesn't leave.
it settles and stays
long past when the clouds scatter,
saturating and chilling,
dealing its damage
until the only thing left to feel
is frost.

Frost & Rain

with hammers and nails,
we built our world
the only way we knew -
with hard labor.

long days
and deep hours
sank into a future
not promised,
not given,
but earned.

love fails when
bricks aren't thick
with mortar,
we knew.

so we watched the
sun set
and moon rise
day after day
until what we
built was a
love
that
worked.

love that worked

i want to write love poems,
like the classics,
because i feel love
like that.
and i try.
and i do.
but i always come back to
writing about heartache and
struggle.
i think it's because those
emotions drive me -
as a person and a maker.
it's not that i live amidst
constant turmoil,
but that turmoil exists
- relentlessly -
inside of me,
driving me,
never letting me settle.
so i rarely write love poems,
at least not like
they were once written.
perhaps it's because
love is the one thing
i got right.

Love Poems

if there ever was a moment
in my short life
that i didn't love you,
i don't remember.

not that i have truly
loved you all my days,
that can't be true,
but all those minutes
before you and i
became you and me,
they're all faded and distant -
erased.

and i watch you as you read,
biting your bottom lip
and shaking your head -
lost in the words.

and i love it.
i love you.

and whatever was
before you,
well none of that matters much.

for everything i've ever
dreamt of,
is now smiling back at me.

Much Matters

"you're confusing."

how so?

"i mean, one minute you're
writing about heartbreak,
the next you're scribbling
about true love."

and?

"and that doesn't make
sense. you can't be terribly
depressed and perfectly
happy all at once."

sure i can. i'm a writer.

in some beautiful way
love
makes us all infinite
we pass it and take it
bits of it
to and from one another
until we are each
connected

i will one day not be
here
but someone i loved
will be
and if that isn't beauty
and if that isn't magic
then what is

infinite love

we give so many
pieces of ourselves
to so many others
no wonder we
struggle to feel
whole

we sat on the short green grass
that edged a small pond,
just beyond the places we would
normally go.
it was afternoon and the sun was
warm against our skin.
and the crystal blue sky shimmered
with possibilities.
"this is good, right? i mean, we're
good?" she asked.
i took a second to respond.
not because i didn't know the answer;
i wanted to savor the question.
the moment.
"yes," i replied. "this, this is everything
i've ever wanted."
she smiled and rested her head
on my shoulder. it was an easy
movement – unscripted and pure.
"good."

Beyond the places

it's a lonely ache

the desire to be seen

and yet it's difficult to show others our true selves

the man behind the curtain

the woman beneath the skin

so we filter and we alter until the image is presentable enough

to be consumed

maybe it's because most of us barely know

how to understand ourselves

how can we expect another person to even get close

to understanding the deepest parts of our soul

it's a paradox or a paradigm shift or some other scientific term

that i read once in a magazine

the truth is being human isn't easy

this desire to be connected to other people

and perhaps a deeper desire to be at peace

with our inner selves

and mostly messing up both

wake myself

i wake myself in the
middle of the night
to make sure that i'm
still breathing.

for life is too short
to end it
by quitting what
i was born to do.

i wanted to know.

but i was afraid to ask.

"so, what am i to you?"

to you?

i struggle with the idea

that we can do anything

to keep her wild,

set her free,

or let her be brave.

she was born with those rights,

so, did someone take them away?

and if so, isn't it pretty sad

some think the power rests

with them to give those powers back?

it's just wordplay.

i understand.

but i never want anyone to feel like

they have the right to set either

of my girls free,

or to let them run.

they were created powerful

and with the ability to use

their own feet.

i'll be damned if anyone

convinces them otherwise.

WORDPLAY

"i love you," she said.

"you're a terrible liar," i replied.

"well, i think i love you."

"then you don't."

"i don't what? think?"

"no. you don't love me if you just think you do."

"oh. i see. you're an expert."

"not really. i just think i love you too."

think so

"alone"
is such
a simple
word
that
makes
me feel
so much.

my brain is broke(n).
it works perfectly fine for most things
but i can't remember a name to save my life.
"do you remember Frank?"
no.
i never remember Frank.
i mean i remember that guy who was about
6'2", 210 lbs, sandy-brown hair, leather briefcase,
coughed six times while i was waiting on a drink,
looked a bit sad but it was probably because he was
alone in a party full of couples
and he had a faint shadow on his ring finger
where a wedding band probably sat
for most of his life.

but i can't remember names.

BROKE(N)

morning breaks

couple of eggs sizzle

in an old pan

salt

pepper

black coffee

with a stack of bills

couple of pills

pen in my hand

scribble and scratch

worry

wonder

what's next

routines

inescapable

i swear

they drive me mad

but here i am

as i just was

doing the best i can

best i can

shame.

shame on you love

for making me feel invincible,

for making this life

so perfectly wonderful

for a time.

shame.

shame on me

for letting love go,

for giving up when

i should have held tight.

shame.

shame on you love

for making me feel

anything at all.

shame

easy

love came easy to us

and life came hard

but we weathered and fought

for the one thing

that was truly ours

your hand on my hand

your lips pressed against mine

simple reminders

of the special connection that

brought us this far

if it wasn't for those
roses you planted
just off the corner of
our small house
i'm certain i would
have choked
on the smog that
covers this pale city.

instead here i am,
after all this time,
breathing in the
beauty that
you once gave roots.

roses and roots

the mind is a terrible thing to waste

mine never seems to shut up

shut off

spinning like a carnival ride

some kid borrowed a dollar

to get sick on

sure those kinds of rides are fun

for a while

but too much cotton candy

or conversations in the dark

and you just throw up

and want to go to sleep

but you can't because the room

is still spinning

and you don't want to waste

your ticket

Carnival Ride

grow up and get a checking account,

withdraw it like a man.

art can't pay the bills for your box house.

fun like that is for kids.

make a dollar like the rest of us,

pick up your shovel and briefcase.

go in debt like the rest of us.

pay your bills off when you're dead.

just give up

like the rest of us did.

be happy to be a rat.

just get by like the rest of us, kid.

you're making us all look bad.

REST OF US

it's a shame
my memories
are made of sand,
so easily scattered
by the days.
because on nights
like tonight,
when the dark blots
out the light,
i'd give anything
just to remember
your face.

i'm not sure you can ever understand love
without living through heartache,
without realizing how fragile such a
beautiful connection can be.

SHAME

scheduled oil change

love?

oh, no.

i don't have time

for such luxuries.

bills to pay,

grass to mow,

and a scheduled

oil change

- it's 2,000 miles

overdue.

6th Street

lost my wallet on 6th street,

it's okay.

only had $3 and a maxed out

credit card.

still pissed though,

been looking everywhere.

your picture is stuck behind

a winning powerball ticket.

sure hope whoever finds my wallet

will send me your photo back.

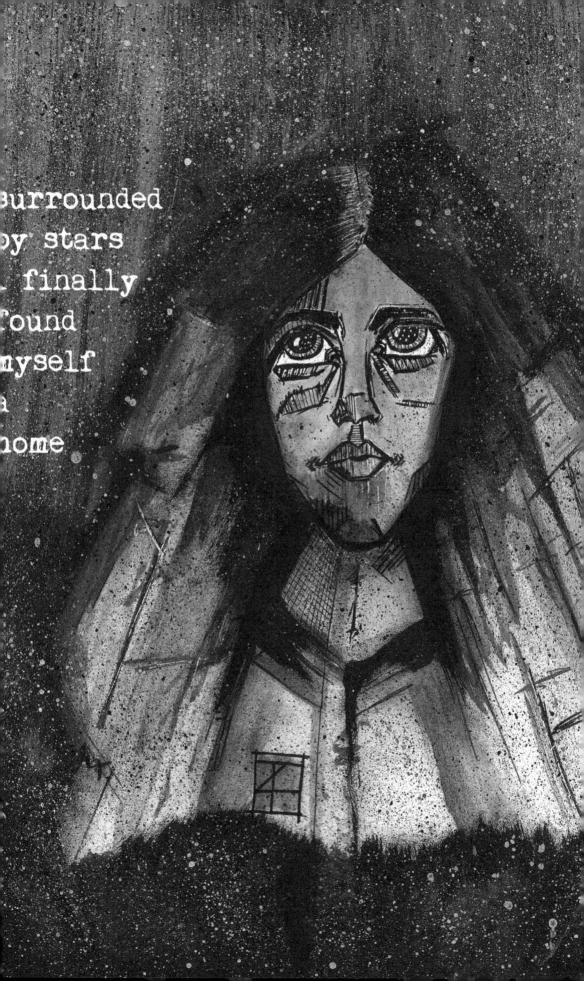

surrounded
by stars
I finally
found
myself
a
home

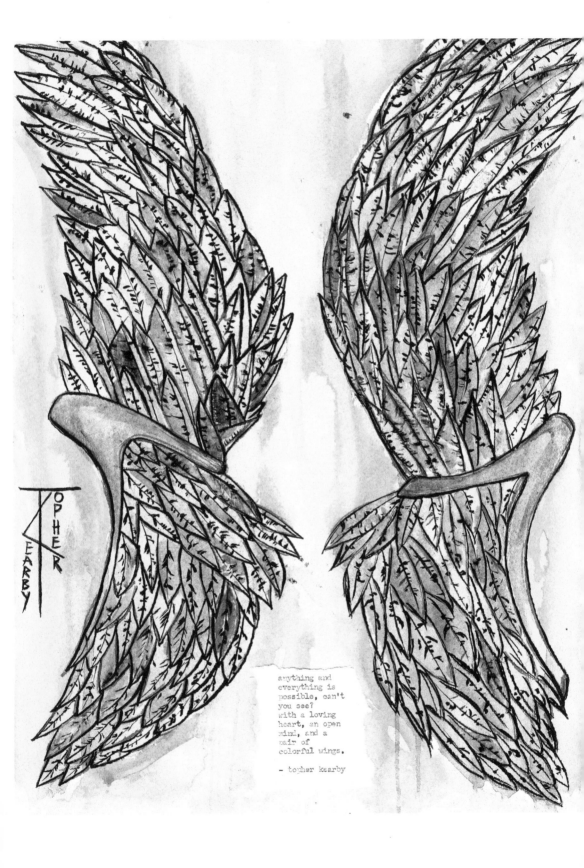

anything and
everything is
possible, can't
you see?
with a loving
heart, an open
mind, and a
pair of
colorful wings.

- topher kearby

car broke down.

donut jelly spilled on my

new shirt.

taxes were due

and all the lions drowned at

the zoo.

(freak flood.)

saw a man kick a mime.

watched a lady stab a dove.

"this world is crazy, man."

must be in love.

crazy, man

we lift our eyes to the infinite

and we feel finite, trivial,

impossibly insignificant beneath

the endless expanse of stars.

dust and bone, we spin in circles

'round a sphere of fire so powerful

it could end our existence

in the time it takes a butterfly

to flap her golden wings.

"then life is meaningless?"

no. far from it.

by realizing our lack of control

over the universe we empower

the gray flesh that sits wrinkled

inside our skulls to be more

than is possible.

for we, mere humans,

hold pieces of the impossible

inside us.

universe

heavy days

heavy rains

thunder

and bags of bricks

weight

slow

steady

moving just

because i have to

seconds morph

into days heart

dropping

to my

feet

it's been just

hours but time

is boundless

when you leave

weight

the many days or few days of our lives

pass by with little conversation

about why or when.

time goes forward,

and perhaps backwards,

and maybe it's all a circle

or a 1970's sci-fi show on AMC.

i don't know.

i do know that i am aging and so are you.

and i love you and that is good.

i'll have someone to cry

at my funeral

and put flowers on my tombstone.

and someone to miss me when i'm gone.

SELFISH TIME

in the mornings we cry
the tears of being human,
and those many drops fill
the mighty rivers
and carry the rushing waters
to the oceans that cover the
earth.
from those tears
our lands are watered,
the people are fed,
and life can be born.

in the mornings we cry
the tears of being human.

tears of being human

i am an ounce of rain

in the ocean of your mind.

a ripple.

a vibration, echoing across

the endless waters

of a lifetime of your

cherished memories.

still, i am happy

to make your mind move;

shaking it even just a bit

each time you think of me

and remember the moments

we shared.

Ounce

depression isn't kind,

it's not a thoughtful guest,

never just finding you on an already bad day.

no, it falls heavy on even the best hours;

maybe even more so.

"don't be sad."

"look at all the…"

please. stop.

depression is no more about sadness than

oceans are about salt.

it's a small part of an endless

body of hurricane-covered waters.

it's encompassing and terrible.

it's delicate and comfortable,

for you recognize its name.

no. depression isn't a friend

with wide shoulders,

it is, as it's been called before,

a subtle beast,

never asking to be invited.

depression

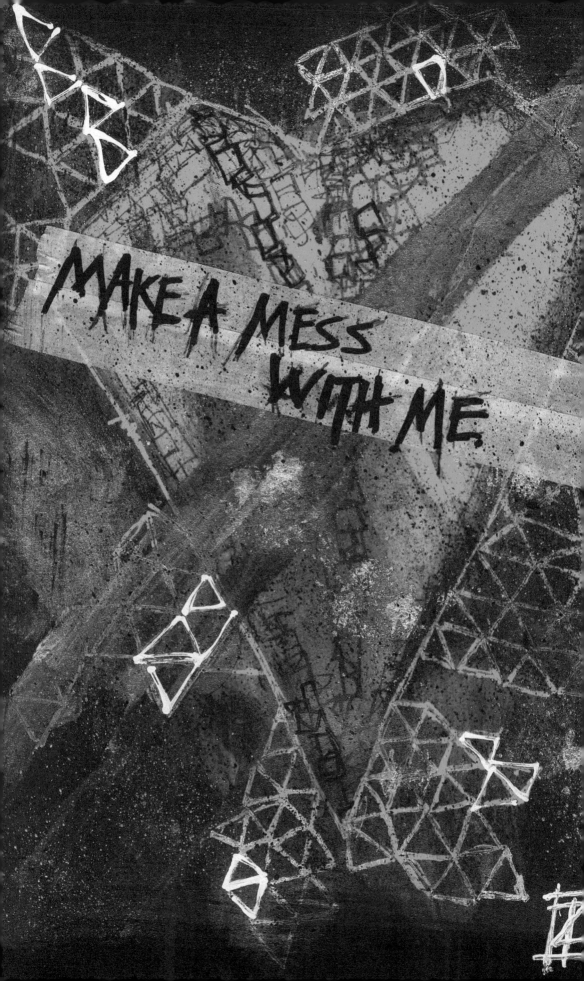

CPSIA information can be obtained
at www.ICGtesting.com
Printed in the USA
LVHW070811011020
667370LV00018B/511